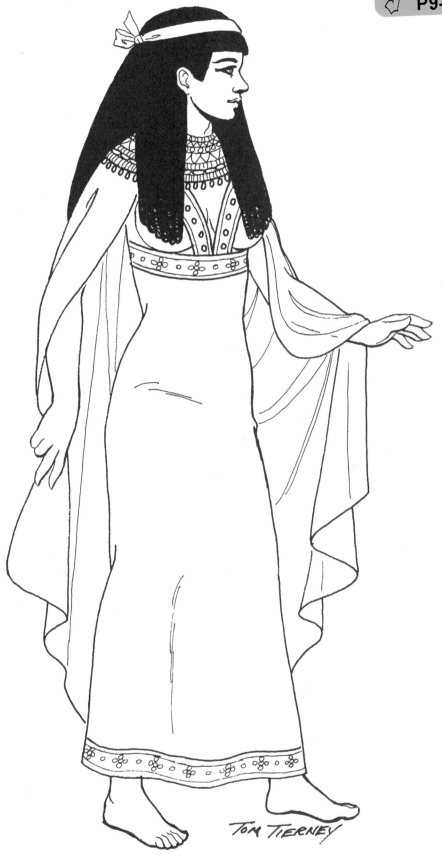

Old Kingdom. *A princess*

She wears a blue, fine linen *kalasiris,* or sheath dress. Banded with embroidered trim, it is held up by two neck straps. Her wig is adorned with a circlet of ribbon. A sheer mantle is draped over her shoulders.

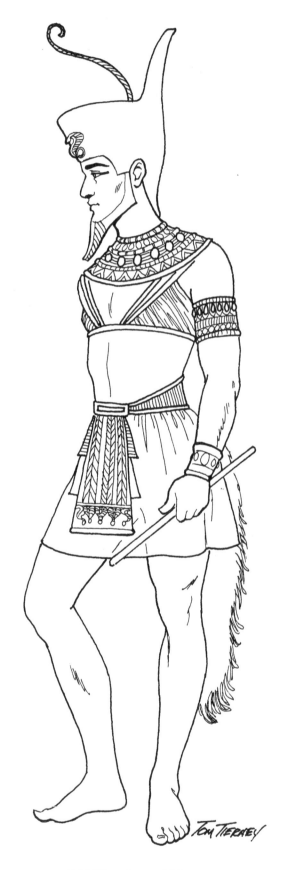

Old Kingdom. *A king*

Wearing the "Red Crown" of lower Egypt, the king wears a jeweled collar, or "corsalet," on his upper torso. Wrapped around his lower torso is a sheer kilt, or *schen-* *ti*. A jeweled loin pendant hangs from the front of his belt, with a fur tail hanging from the back.

Ancient Egyptian Fashions

Tom Tierney

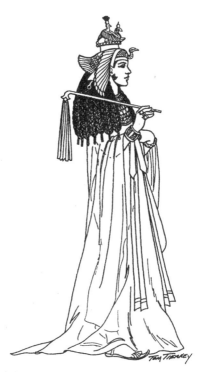

DOVER PUBLICATIONS, INC.
Mineola, New York

Introduction

Archeologists estimate that ancient Egypt was established about 3100 B.C., a result of the union of upper Egypt (the Nile Valley) and lower Egypt (the Nile Delta). Its history has been divided into three important eras, separated by periods of turmoil: the Old Kingdom (c.2686 to 2160 B.C.), the age of pyramid building; the Middle Kingdom (c.2040 to 1786 B.C.), the period of power and growth; and the New Kingdom (c.1570 to 1085 B.C.), which began in magnificence and ended with Roman conquest.

Over the course of three thousand years, ancient Egyptian fashions changed only imperceptibly. People wore draped, sheer garments–loincloths, skirts, capes, and robes–fastened with knots, belts, or sashes.

Clothing in the Old Kingdom was notable for its simplicity. Men wore kilt-like skirts called *schenti*, which evolved from loincloths. Variations on this style depended on the wearer's rank, as well as the occasion.

Women wore tightly wrapped sheaths called *kalasiris*. Falling from below the breast to the ankle, it was held up by one or two straps. The *kalasiris* evolved into a style that was sewn down one side; eventually, *kalasiris* came to describe any seamed, dress-like piece of clothing worn by men and women.

Laborers and slaves, if clothed, wore only loincloths. For a slave, often the sole covering was a cloth belt inscribed with his or her master's name.

In ancient Egypt, nudity was a natural state. Children and slaves living in the early dynasties were unclothed. Clothing was a status symbol, but cleanliness was more important.

To keep clean, men and women shaved their bodies, including their heads. They wore wigs, which could be washed or replaced, to protect their scalps from the powerful sun. Wigs, which appear to have been made from rolled strips of corn, were often braided. Beards were considered symbols of power, so pharaohs wore false wooden beards which were held in place by chin straps.

During the Middle Kingdom, jewelry became more refined and brightly colored. Crafted in gold, it was often set with semiprecious stones, including lapis lazuli and garnets.

With the influence of outside cultures, New Kingdom clothing became layered and more varied. Pleated and gathered fabrics in rich primary colors were popular, although diaphanous robes and gowns were usually white. Cloth produced in this period was so finely woven, that even today it cannot be duplicated.

By the time of the New Kingdom, men had discarded the *schenti* in favor of skirts made from linen rectangles which were folded into single box pleats at the front. The nobility wore skirts made from more generous amounts of fabric that fanned into wide, single triangles in the front. They were fastened with decorative belts. Hanging from each skirt was a wedge-shaped apron, elaborately embroidered, and adorned with precious stones. The front-piece, without the decoration, was adapted by the lower classes.

Another style introduced during the New Kingdom was a sleeved tunic which resembled a short-sleeved nightshirt. But the most unusual garment of this period was made from a rectangle of fabric about twice the height of the wearer. It was folded down the center and had a slit cut for the head. The sides, sewn from hem to waist, were caught up and tied in the front, creating voluminous sleeves. Inspired by a style from Asia Minor, it was worn in ancient Egypt both by men and women.

Throughout Egypt's ancient history, most people, including royalty, went barefoot. During the New Kingdom period, however, people of rank began to wear papyrus and palm leaf sandals for ceremonies. Nobles wore gloves.

Bibliographical Note

Ancient Egyptian Fashions is a new work, first published by Dover Publications, Inc., in 1999.

International Standard Book Number
ISBN-13: 978-0-486-40806-4
ISBN-10: 0-486-40806-X

Manufactured in the United States of America by RR Donnelley
40806X08 2015
www.doverpublications.com

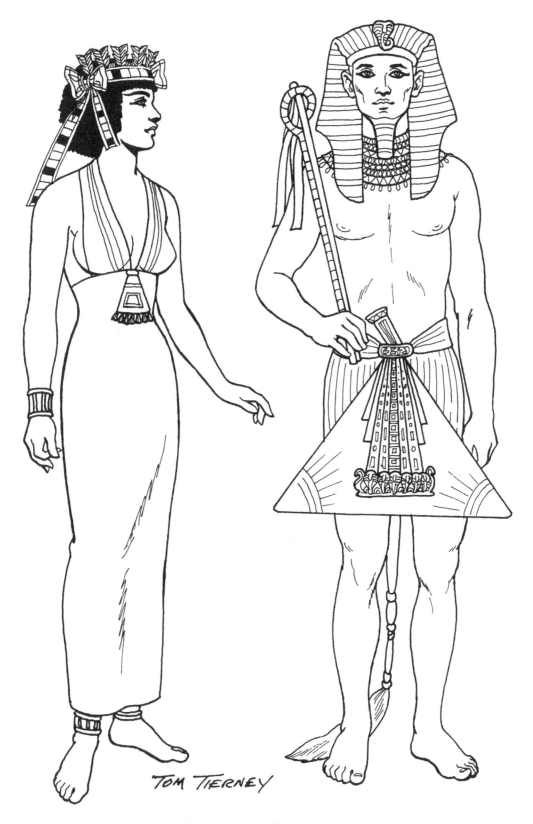

TOM TIERNEY

Old Kingdom. *A king and a woman*

The king wears a loincloth fashioned from pleated, gold fabric. A symbolic lion's tail is attached to the back. From his waist hangs a stiffened triangle of embroidered fabric covered with a jeweled loin pendant. The king carries the royal crook and flail, signs of his authority. A jeweled club is tucked into his waistband. The woman wears a sheath with two shoulder straps. A jeweled pendant hangs from her neck. On her head is a ribbon circlet with gold feathers arranged to form a coronet.

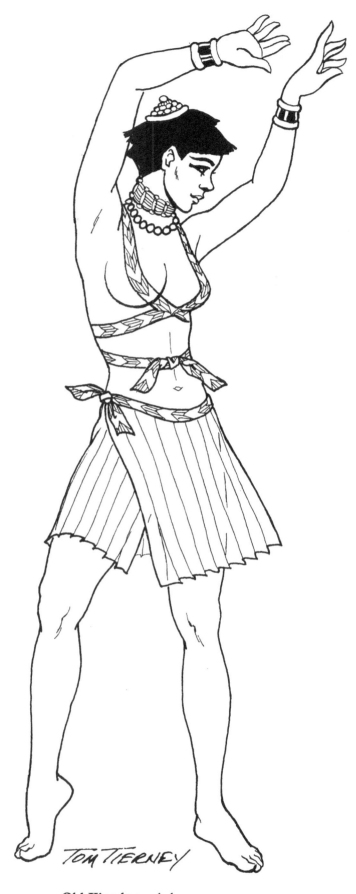

Old Kingdom. *A dancer*

This dancer wears a sheer, knee-length, pleated kilt. Riding low on the hips, the kilt is held with a ribbon. A matching ribbon loops around her neck, crosses over her chest, and ties at her waist.

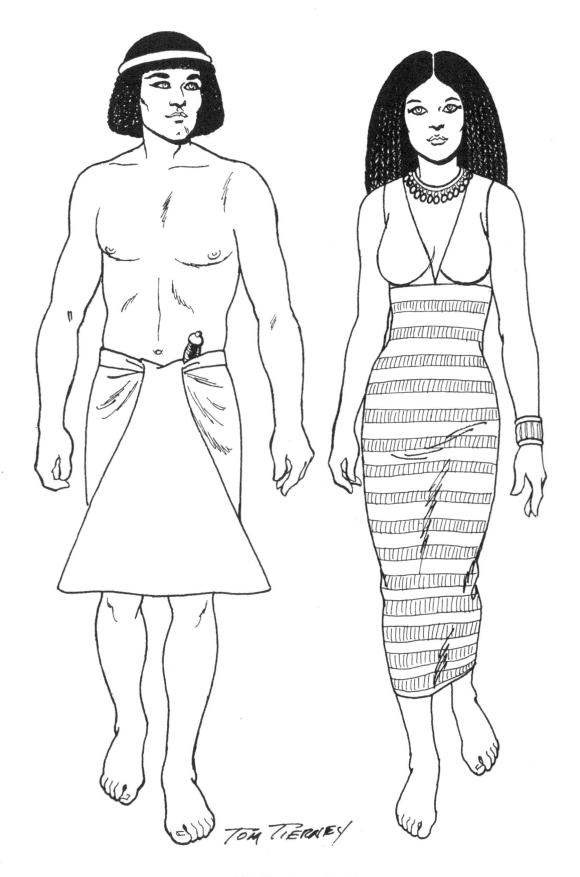

Old Kingdom. *A scribe*

The man, probably a scribe, wears a knee-length kilt, the front of which is covered by a starched apron of the same fabric. A baton is tucked into his waist. The woman wears a striped sheath with broad shoulder straps, and a jeweled collar.

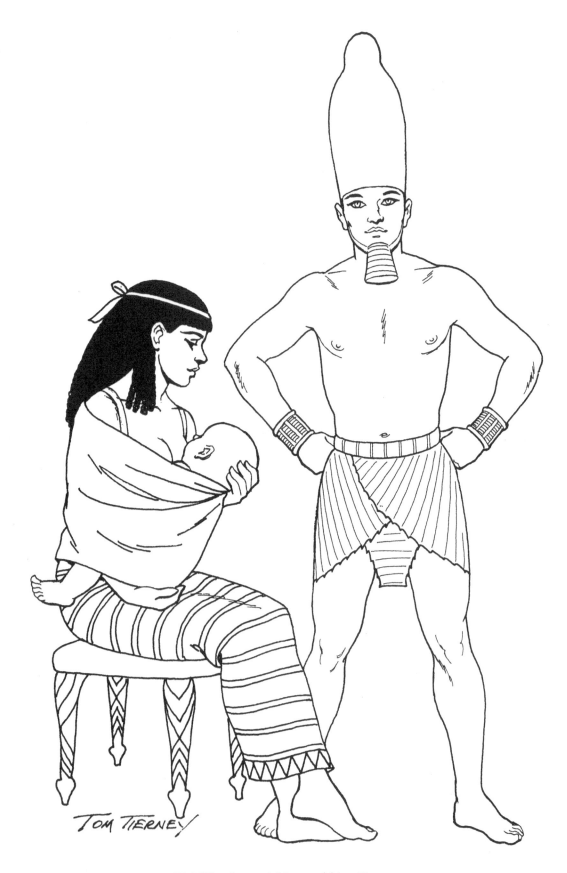

Old Kingdom. *A king and his wife*

The king wears a *schenti* made of pleated fabric which is fastened at the waist by a belt. During the Old Kingdom, men wore bare torsos. This king wears the "White Crown" of upper Egypt and the royal ceremonial false beard. His wife wears a striped sheath with narrow shoulder straps. She nurses her baby whom she supports with a square of fabric wrapped into a sling.

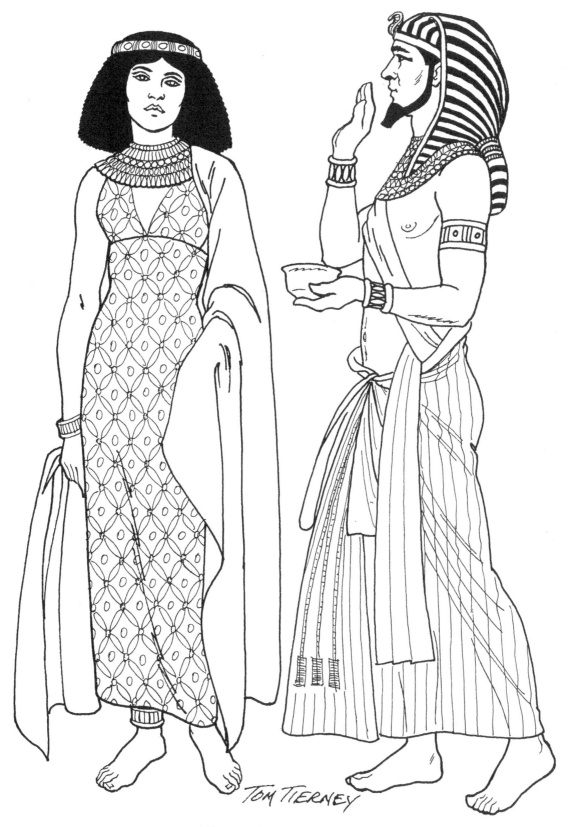

TOM TIERNEY

Middle Kingdom. *A king and a woman*

The king's clothing, worn as priestly garb, reflects a transition into the New Kingdom. Of sheer pleated linen, it is tied in the front to form a stiffened and embroidered loin pendant. On his head he wears the *khat,* a cloth wig cover which is pulled to the back and tied like a ponytail. On the front of the *khat* is a golden *uraeus,* a cobra emblem denoting power. Across the king's chest is a folded cloth which acts as a suspender. The woman wears a *kalasiris,* in the style of the Old Kingdom. Made of a lightweight, multicolor linen, it has wide shoulder straps. She wears a mantle made of heavier linen, as well as a collar, diadem, bracelets, and a wig.

11

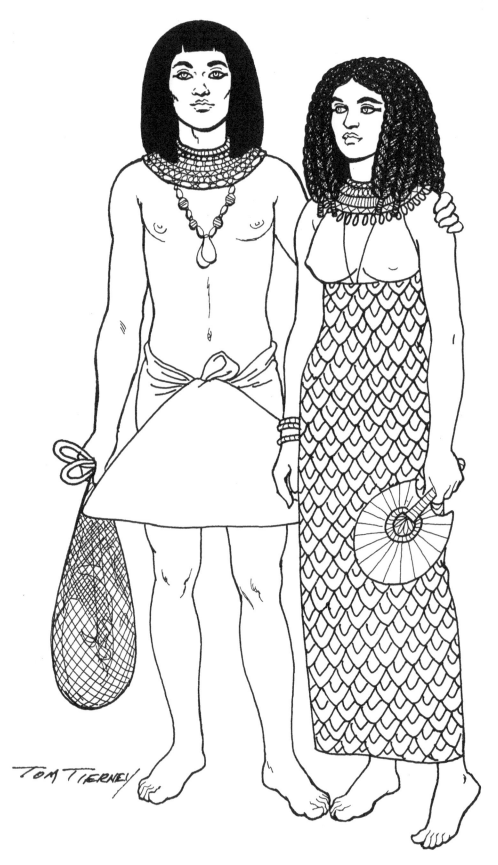

Middle Kingdom. *A man and a woman*

The man wears a loincloth covered with a starched and stiffened triangle. At his neck is a jeweled collar and a pendant . His torso is bare. He carries a fish in a net bag.

The woman, wearing a scale-patterned sheath with broad shoulder straps, carries a straw fan. Her wig has been corn-rolled and braided.

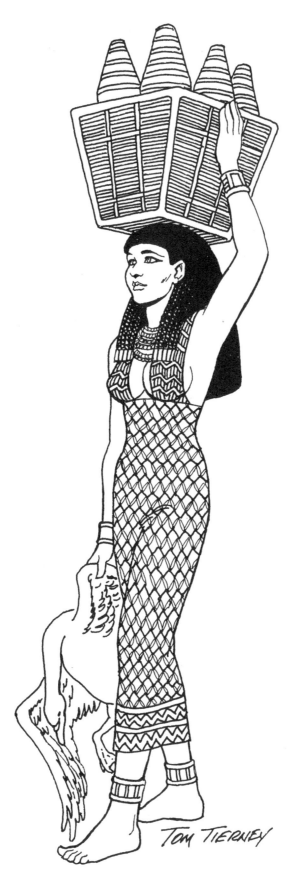

Middle Kingdom. *A maidservant from the court*

Carrying a basketful of vases on her head and a goose for cooking, she wears a sheath, or *kalasiris,* with wide, beaded shoulder straps. Her body sheath is overlaid with a net made from multicolor leather strips.

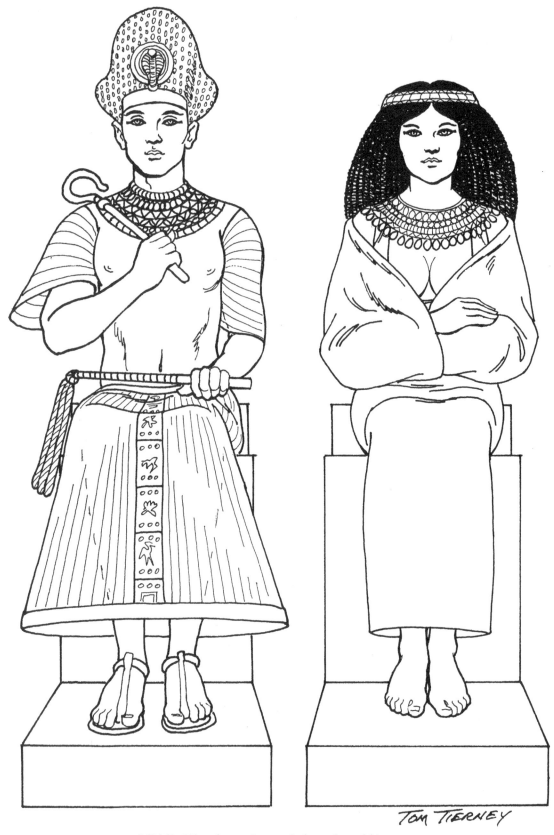

Middle Kingdom. *A seated pharaoh and his queen*

On his head is the "Blue Crown." Trimmed in gold, it is studded with gold brads. The pharaoh wears a long, pleated, sheer linen overskirt with a pleated shawl around his shoulders and arms. He carries the royal crook and flail. His power is affirmed by the golden *uraeus,* or cobra, on his crown. The queen wears a sheath in the style of the Old Kingdom. Under the long, linen wraparound stole are two shoulder straps. Both king and queen wear jeweled collars.

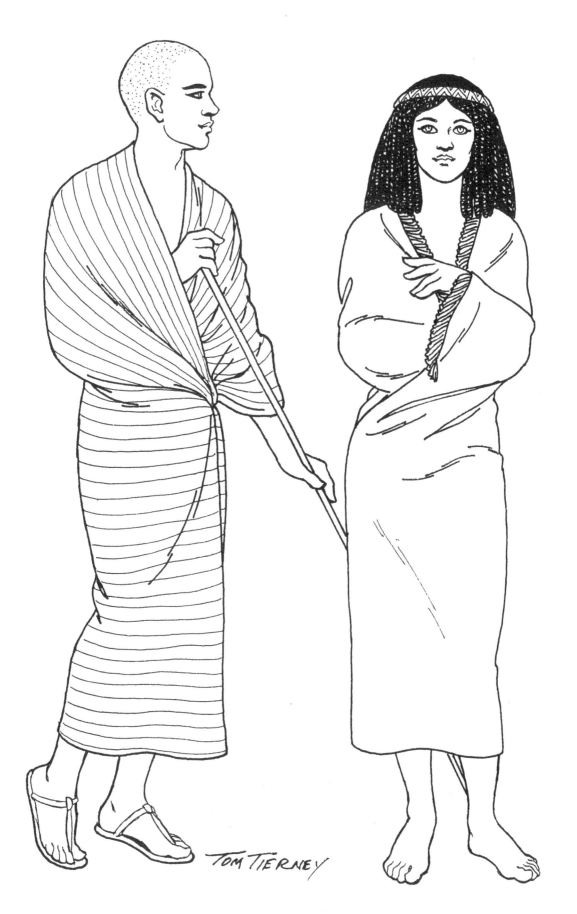

Middle Kingdom. *A man and a woman*

Both are clad in blanket-shaped garments which wrap around their bodies with little draping. These coverings were worn at night to ward off the desert chill. The man's stole is made of striped fabric.

15

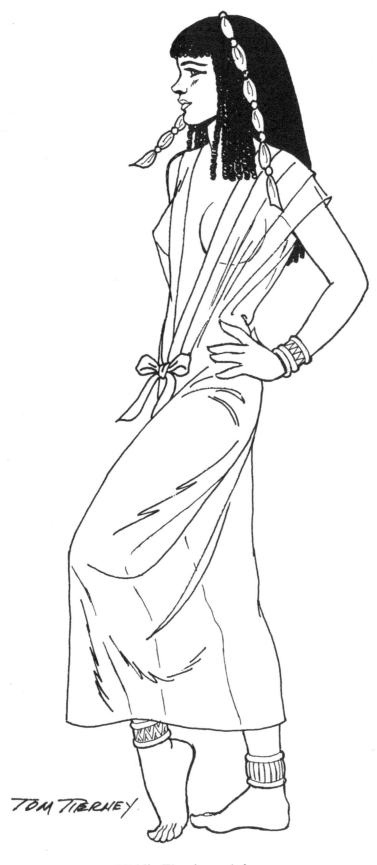

Middle Kingdom. *A dancer*
She wears a sheer, calf-length robe that ties in the front.
Knotted ribbons adorn her wig. She may be attired for
a funerary event or high religious festival.

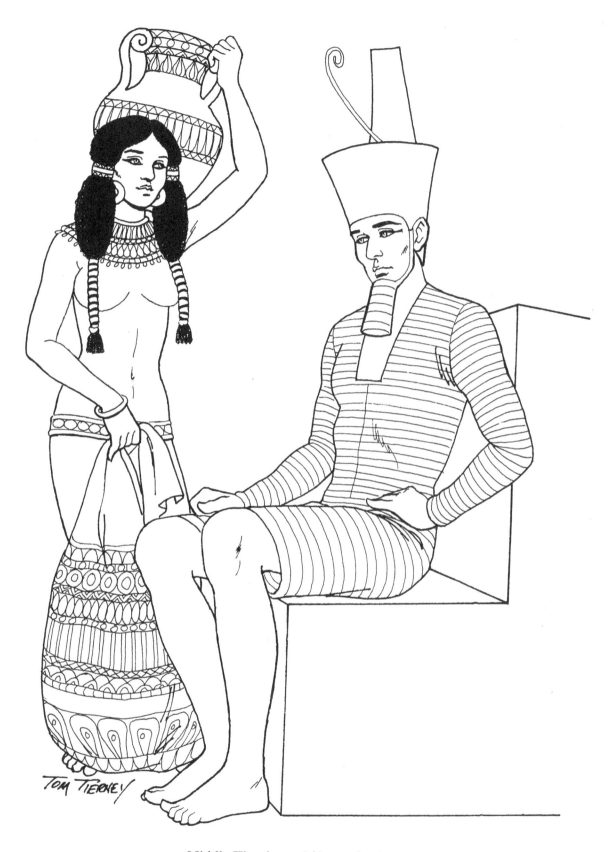

Middle Kingdom. *A king and a slave*

The king wears a fitted, long-sleeved sheath made of striped material for the jubilee festival in which rites are performed to restore his youth and power. On his head is the "Red Crown" of lower Egypt and he wears the royal false beard. The slave carries an urn and a decorated bag filled with religious paraphernalia. She wears a jeweled collar and belt.

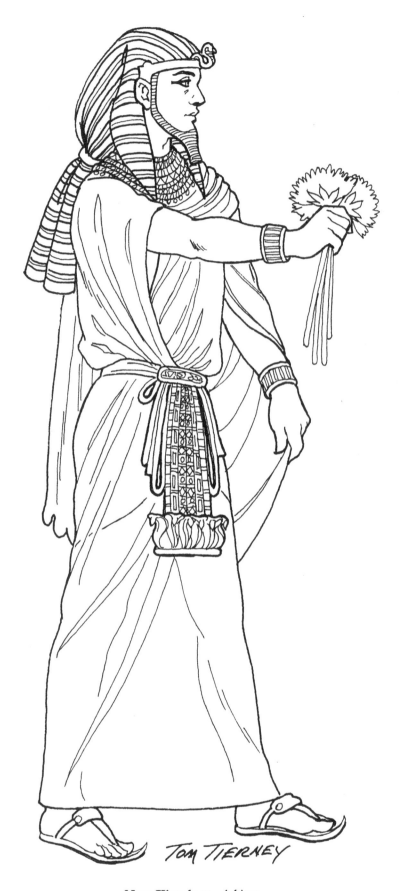

New Kingdom. *A king*

The king wears a cloth *nemes,* or wig cover, which is gathered in back like a plait, or pigtail. He wears a diaphanous linen robe over a *schenti.* A jeweled loin pendant hangs from his belt.

18

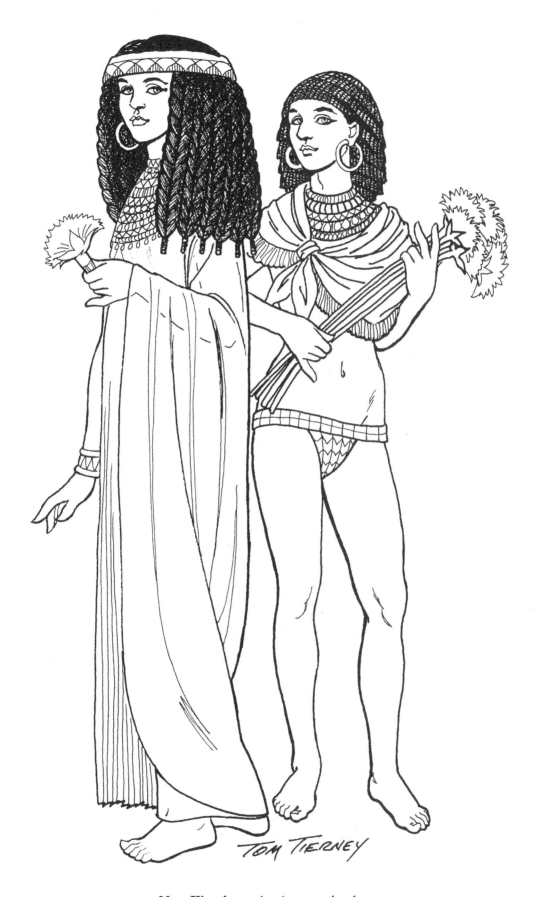

New Kingdom. *A princess and a slave*

A jeweled circlet adorns the princess's braided wig. She wears a diaphanous mantle over a sheer, pleated sheath.

The slave wears a fringed mantle around her shoulders, tied at the bosom, and an embroidered chastity belt.

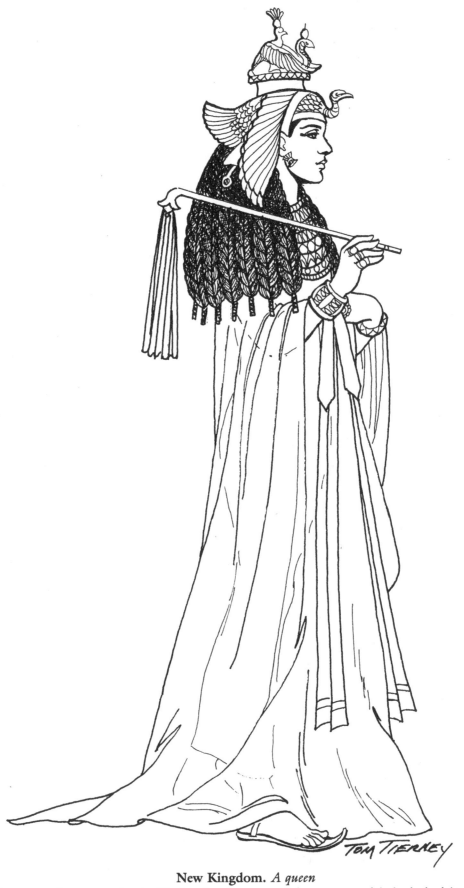

New Kingdom. *A queen*

She wears a sheer mantle over a sheath. On her head rests the sacred vulture headdress of a queen. She carries a royal scourge and is bedecked in jewels, including a jeweled collar.

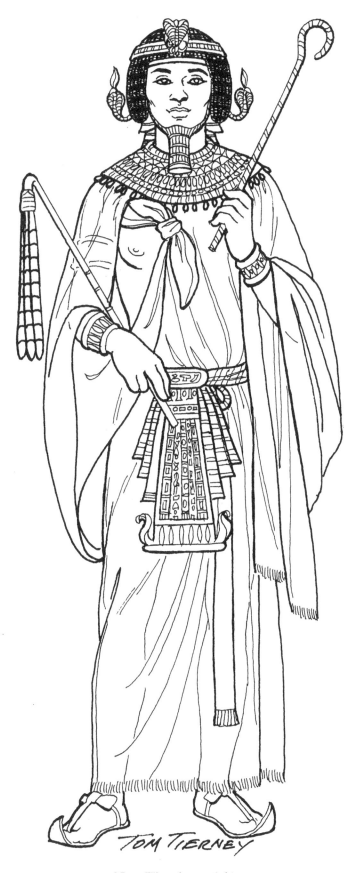

New Kingdom. *A king*

He wears a blue wig adorned with a diadem and three golden *uraeus,* as well as a false royal beard. His gold collar is set with blue and white stones. Under the collar is a mantle which is draped and tied at the chest. A jeweled, red, blue, and gold loin panel hangs from his belt. He carries the royal scourge and crook.

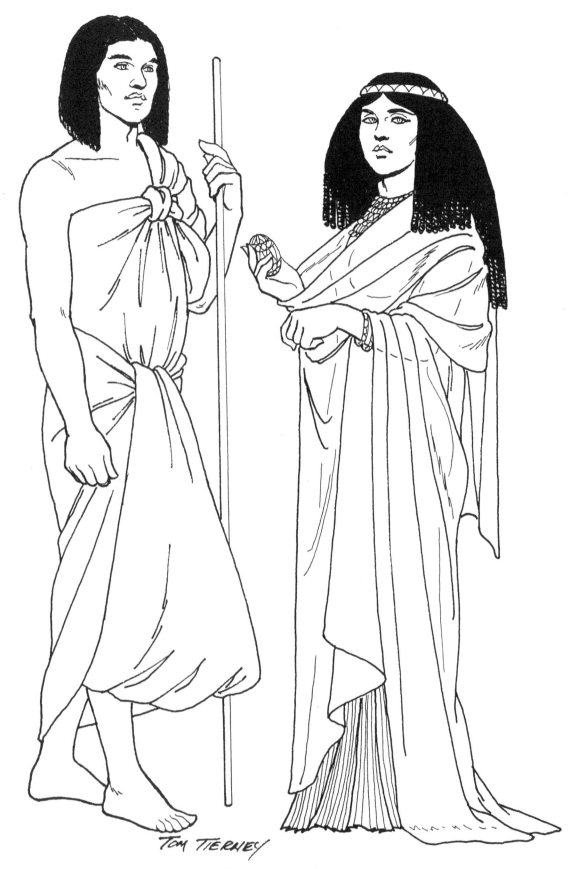

New Kingdom. *A noble couple*

Dressed for a funeral, the man wears a linen cloth which is draped over one shoulder and knotted at the chest. A second cloth is wrapped around his hips and arranged in the front to form a full loin pouch. The woman wears a sheer mantle over a pleated robe.

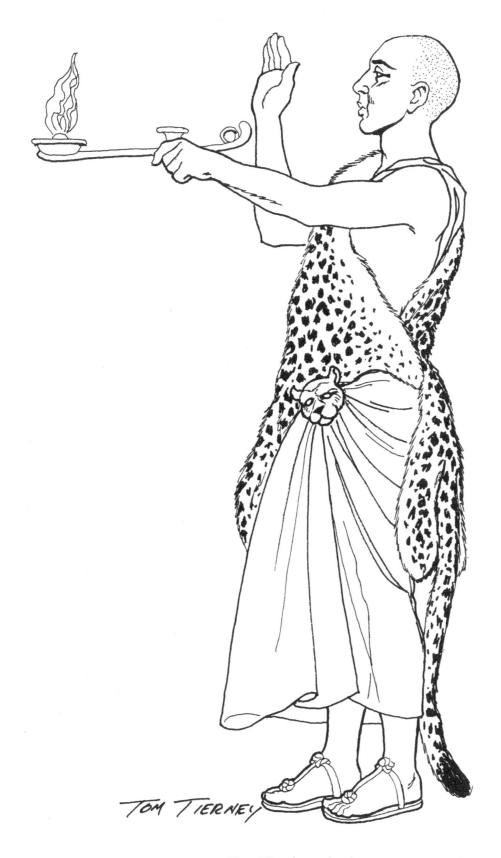

New Kingdom. *A priest*

Making a sacrificial offering, the priest wears a long, sheer skirt draped to the front and caught with an ornamental cat's head. A leopard skin mantle, draped over one shoulder, falls to the back, the tail touching the floor. Diagonally across his chest, he wears a band of folded fabric in the manner of a baldric. It is probably a lector's sash, indicating that he is a religious teacher.

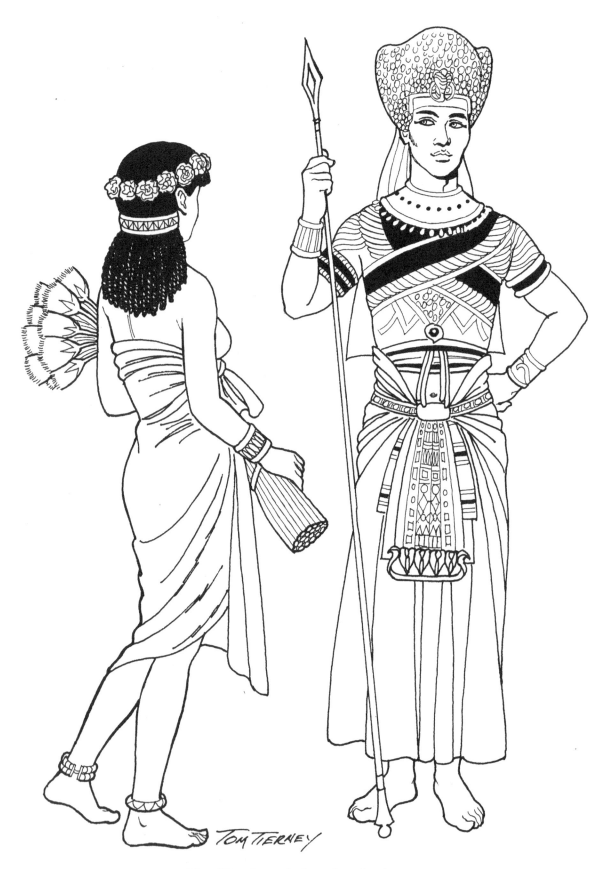

New Kingdom. *A pharaoh and a slave*

The pharaoh wears the royal "Blue Crown" trimmed in gold and studded with blue. Hanging from it is a scarlet neck cloth called a *cheperesh*. His vest is embroidered with the sacred vulture's wings in black, green, and gold.

His collar is gold. He wears a long, sheer skirt draped to the front, and a multicolored belt with loin pendant. The slave, carrying lotus blossoms, wears a pale green, sheer cloth draped and tied at her waist.

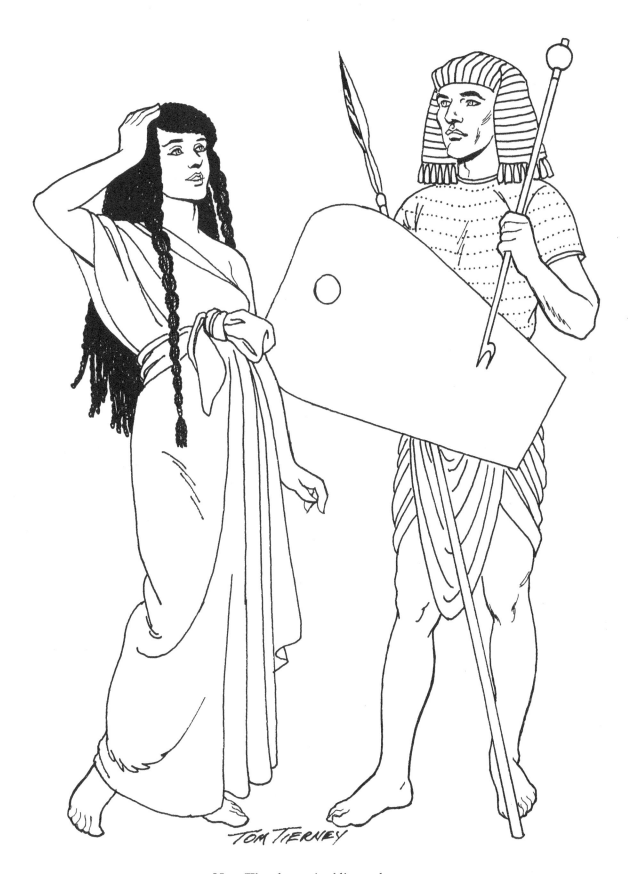

New Kingdom. *A soldier and a woman*

The soldier wears a cloth headpiece styled like the *khat,* but without a wig. He wears a shirt and loincloth. From his belt hangs a heart-shaped leather loin piece. He carries a shield, club, and spear. The woman wears a large square of coarse linen draped over one shoulder, tied at the waist.

25

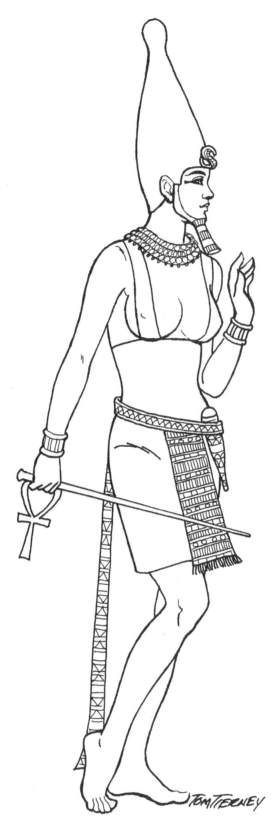

New Kingdom. *Queen Hatshepsut*

One of the most colorful characters in Egyptian history was Queen Hatshepsut who declared herself a man in order to rule as pharaoh. Here she is seen in a combination of male and female attire. She wears the king's "White Crown" of upper Egypt and the ceremonial false beard. Her *kalasiris*, or sheath, is strapped in the style of the Old Kingdom, but is cut short like a man's *schenti*. She wears a beaded loin panel. Tucked into her belt is a decorated cudgel. An embroidered tail hangs from her back.

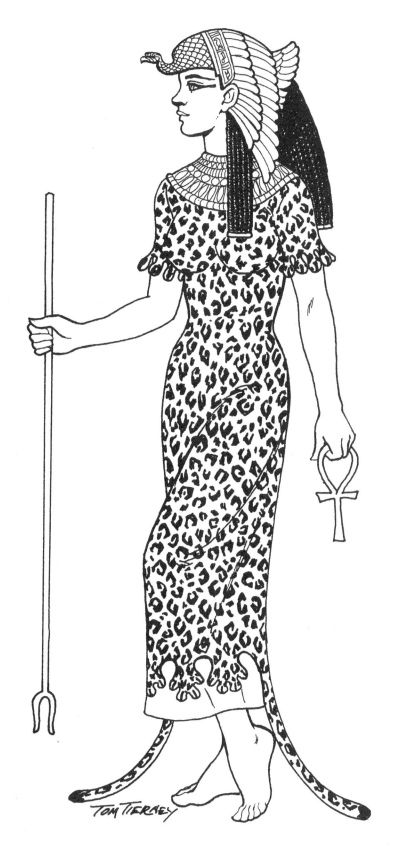

New Kingdom. *Queen Hatshepsut*

Queen Hatshepsut appears here as a woman in an adaptation of priestly ceremonial robes. She wears the queen's vulture headdress and a jeweled collar. Her dress is made of leopard skin and has a leopard paw motif at the sleeves and hem, with two tails trailing. A sheer sheath is visible underneath. She carries a *was* scepter which symbolizes the support of heaven, and an *ankh*, which represents life.

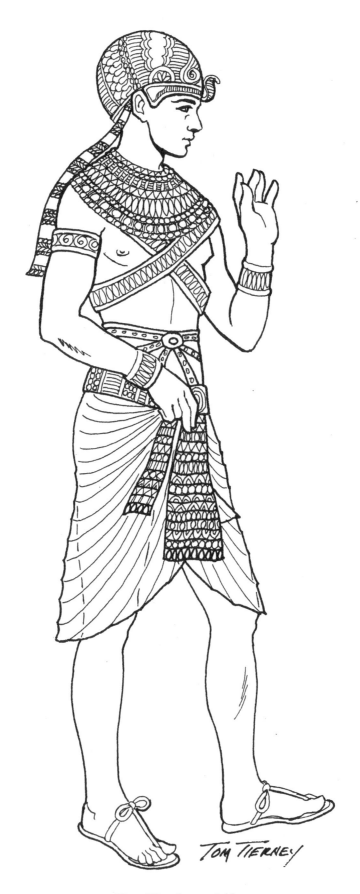

New Kingdom. *A king*

He wears a rounded variation of the "Red Crown" and a very wide jeweled collar. Two jeweled leather *ban-* *doliers* cross his chest. His sheer, pleated, yellow gauze *schenti* is fastened by a decorated belt and front panel.

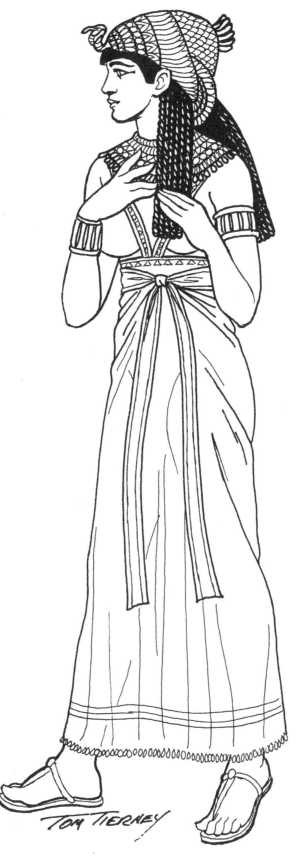

New Kingdom. *A queen*

This queen wears a multicolored stone and gold vulture headdress with a beaded collar. Her straight, sheer, linen sheath is draped and belted at the waist. The sheath has two jeweled shoulder straps rising from the center.

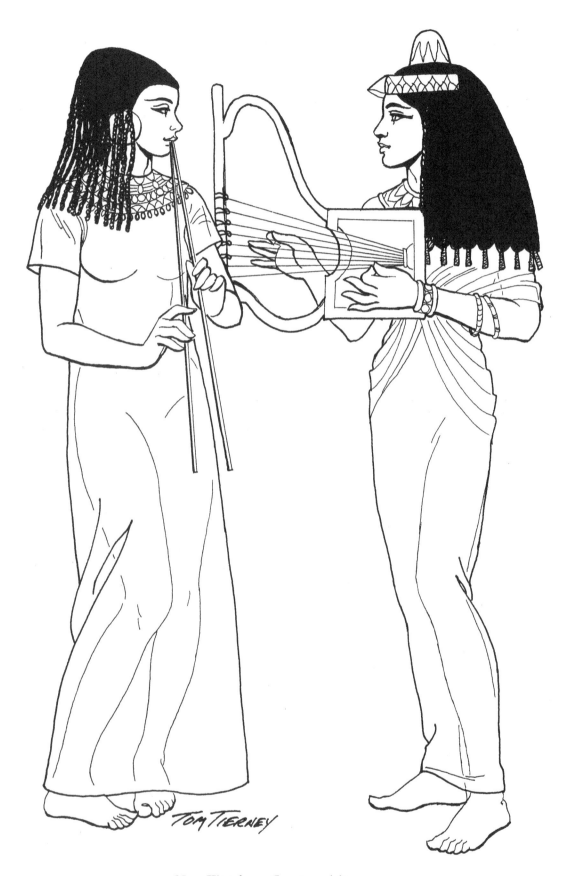

New Kingdom. *Court musicians*

The reed flutist on the left wears a sheer, loose robe. The stringed instrument player on the right wears a sheer sheath which is tightly wrapped and draped over one arm. On her head she wears a half circlet and a perfumed cone made of fat. As the fat melts in the heat, it scents the wearer.

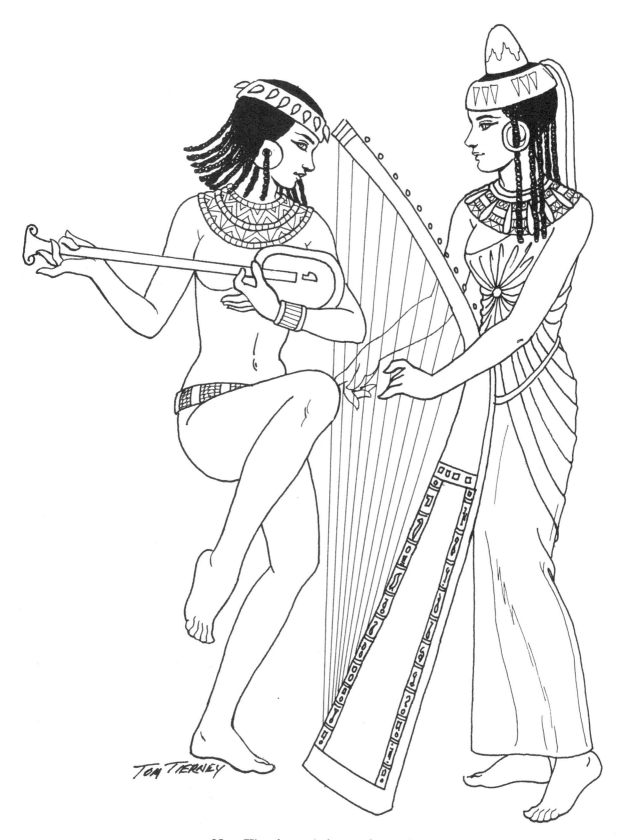

New Kingdom. *A slave and a musician*

On the left, the slave dances and strums a guitar-like instrument. She wears a typical beaded collar and belt. Adorning her head is a decorated circlet and her hair appears to be in loose corn-rolls. Her large disk earrings are a relatively new style. The harp player wears a long, sheer sheath. The draped mantle is caught and gathered beneath the bosom by a jeweled pin. On her hair, which is also corn-rolled, she wears a heavy circlet with a ribbon down the back and a perfumed cone.

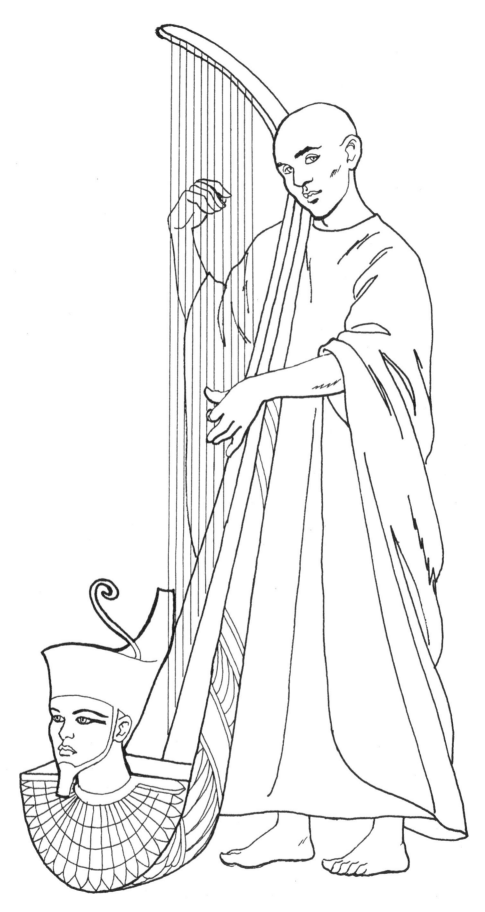

New Kingdom. *A harp player*
This man wears a loose, coarse linen robe.

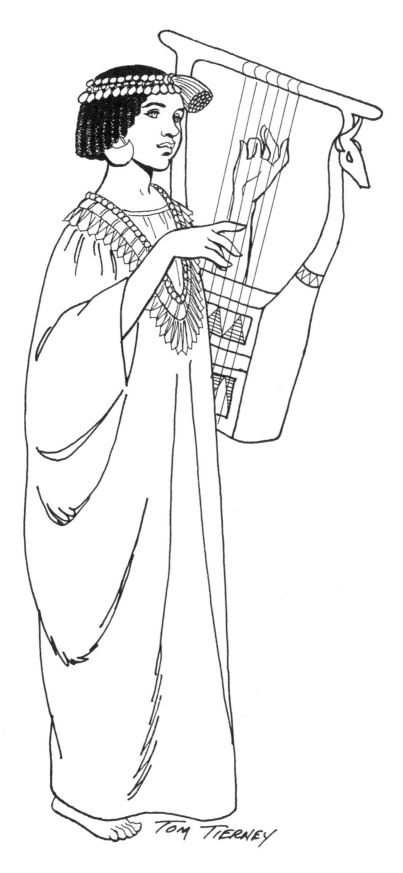

New Kingdom. *A woman*

This woman is playing a small, harp-like instrument. She wears an undraped robe with a necklace in place of a collar. Atop her short, corn-rolled wig is a beaded circlet, a lotus blossom tucked into it.

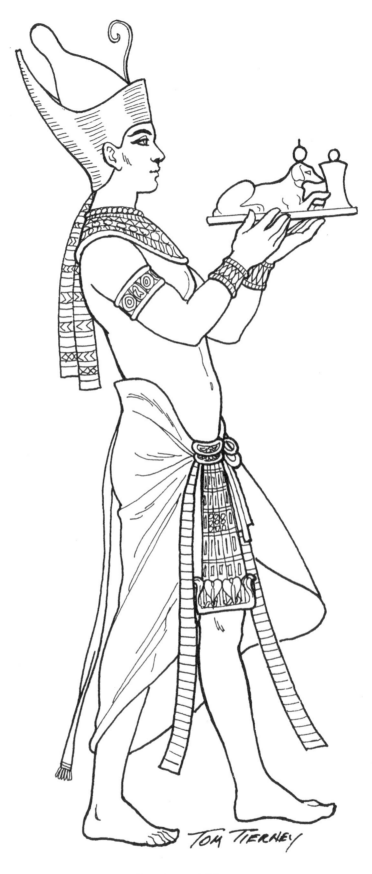

New Kingdom. *A king*

Offering a golden ointment box to the gods, this king wears the double crown with its "White Crown" top and "Red Crown" bottom. At his neck is a jeweled collar. He also wears a wide, royal loincloth of sheer linen, and a jeweled loin pendant.

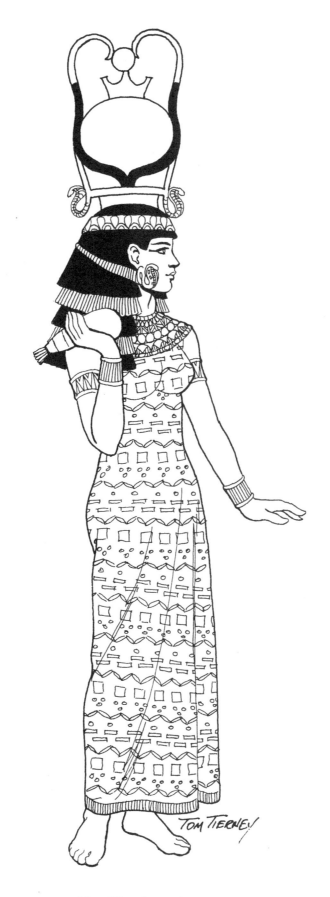

New Kingdom. *A queen*

Dressed in the ceremonial garb of the goddess, Hathor, the queen wears a beaded and embroidered *kalasiris,* and a jeweled collar. The gold and black headdress is ornamented with a red sun disk.

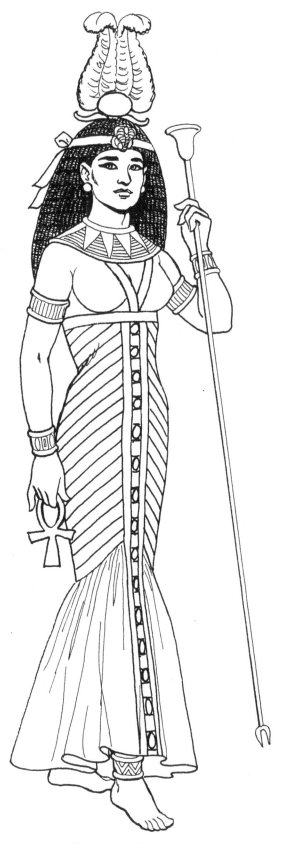

New Kingdom. *A queen*

This queen is dressed in ceremonial robes as befits the wife of the god, whom her husband represented on earth. She wears a narrow blue and white striped tunic over a wide, sheer under gown with red shoulder straps. Her gold collar and bracelets are set with green stones.

Her headdress is decorated with a red sun disk, golden plumes, and goat horns. She wears a red bandeau of ribbon with the gold *uraeus*. She carries an *ankh* and a lotus scepter.

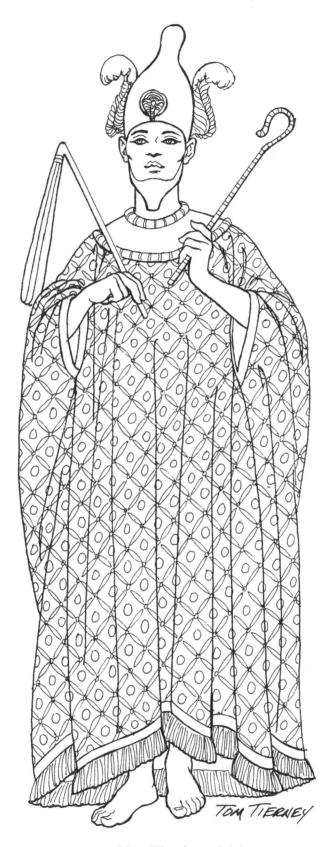

New Kingdom. *Osiris*

According to legend, Osiris, originally the god of agriculture, was killed by the god of darkness and transformed into the god of the underworld. Shown here, he wears a gold crown with white plumes, and a white, royal beard. He carries the royal scourge and hook. Following tradition, his skin is painted green. His robe is mauve with rose disks and purple fretting; the arm bands and fringe are white.

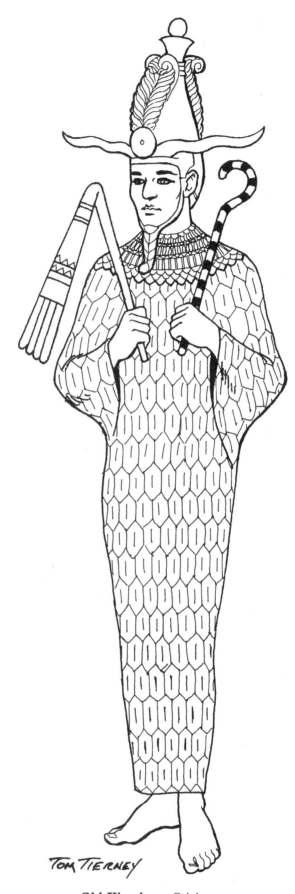

Old Kingdom. *Osiris*

Osiris was often shown posed as a mummy, tightly wrapped in a linen shroud. Here the shroud is patterned.

He wears the *atef* crown, similar to the "White Crown," but with the addition of goat horns.

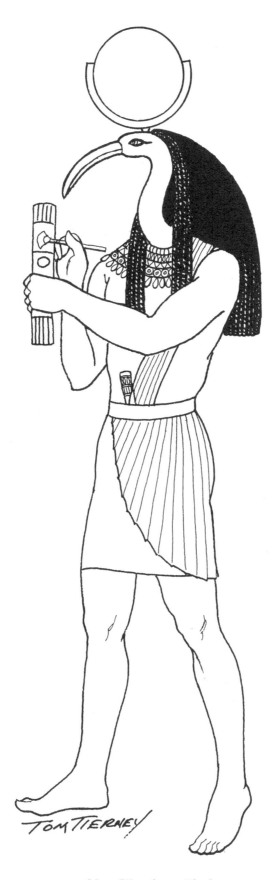

New Kingdom. *Thoth*

Thoth, the ibis-headed god of writing, was scribe to the gods. He is wearing a pleated *schenti* and a lector's sash.

In addition to the ibis, Thoth sometimes appeared as a sacred ape.

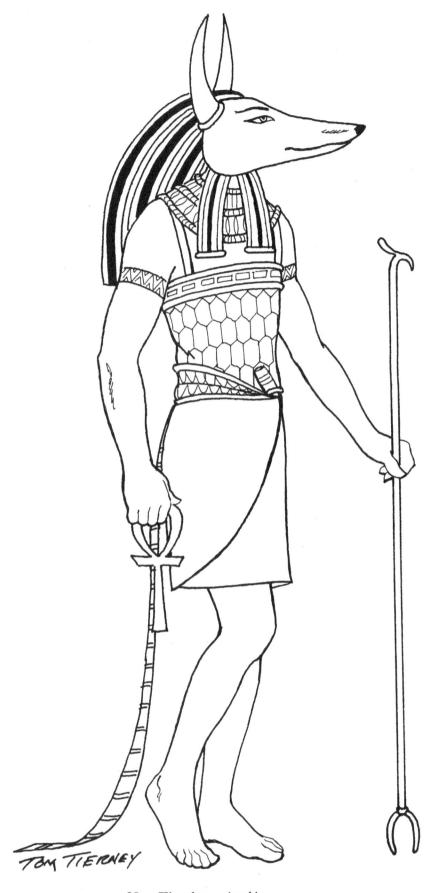

New Kingdom. *Anubis*

The jackal-headed god of burial and embalming, Anubis is wearing an archaic two-strapped tunic covered with a *schenti*. An ornamental tail hangs from his belt. He holds the *was* scepter and an *ankh*.

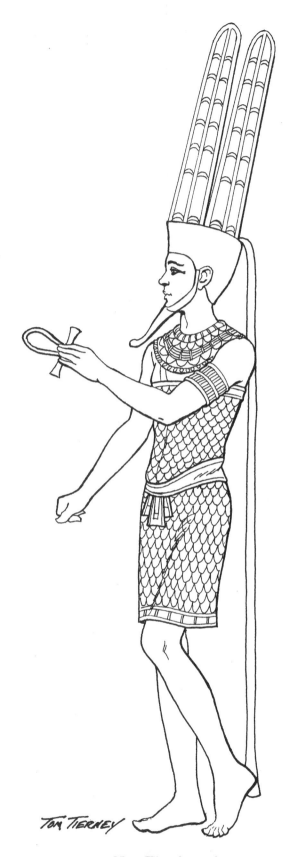

New Kingdom. *Amun*

Pharaoh Ikhnaton, in an attempt to reform the Egyptian religion, declared that there was one god, whom he called Amun. Here Amun is shown wearing an archaic, scale patterned tunic. His flat topped crown has stylized plumes made of bent reeds. A royal tail is attached to his crown. He holds an *ankh*, the symbol of life. When Ikhnaton died, Amun was discredited.

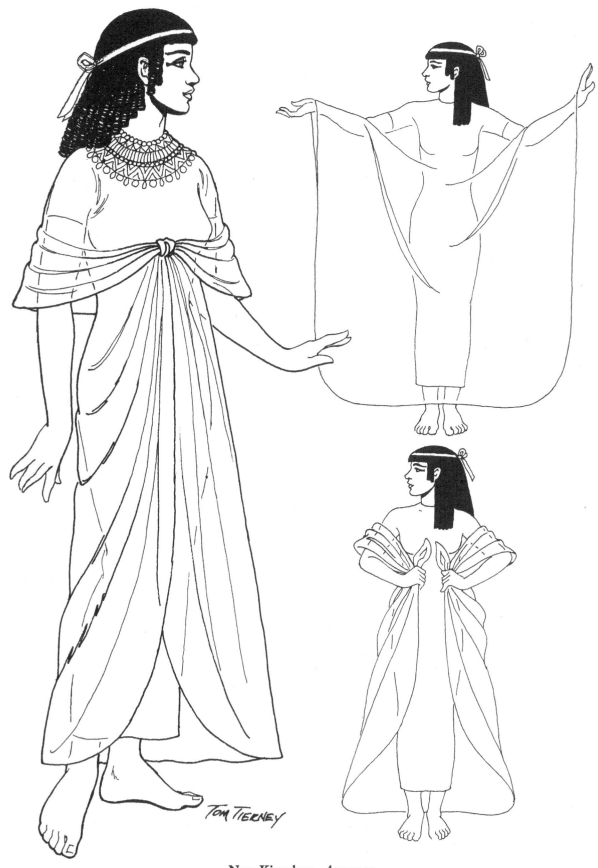

New Kingdom. *A woman*
This diagram shows how to drape and tie a square, sheer
robe over a *kalasiris*.

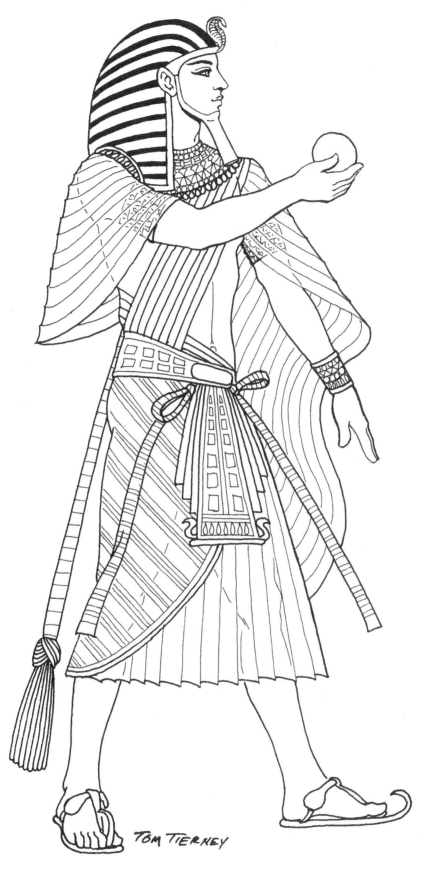

New Kingdom. *A king*

The king is wearing the *nemes* headcloth with an *uraeus,* a jeweled collar, and a sheer shawl. The *schenti,* which covers a sheer kilt, has a jeweled frontal pendant. He also wears a lector's sash and a decorative, royal tail.

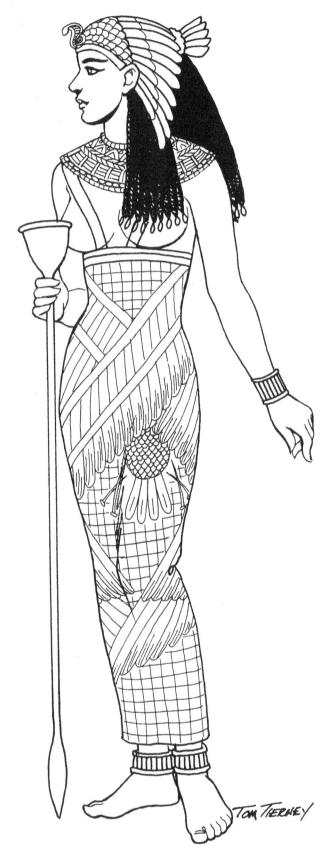

New Kingdom. *A queen*
She wears the gold and jeweled vulture headdress, a
broad jeweled collar, and a richly embroidered *kalasiris*.

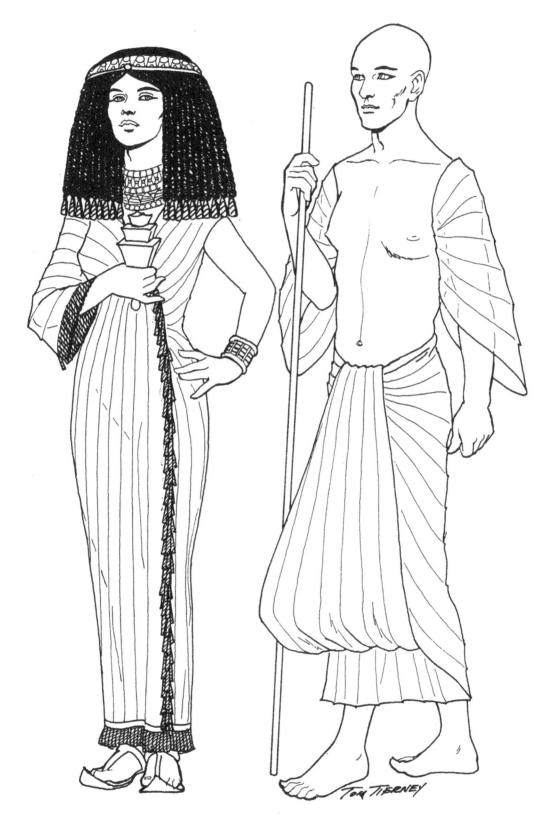

New Kingdom. *A noblewoman and nobleman*

This noblewoman wears a fringed *sari*-like garment made of pleated, sheer linen. Wrapped tightly around her, it covers one arm and is secured in front with a pin. She holds what appears to be a perfume container. Her wig has golden tassels at the end of each lock, and she wears a jeweled circlet. The man, probably a viceroy or other official of the court, wears a sheer, pleated shawl over his shoulders and arms. His long skirt, made of the same fabric, is arranged to form a full loin pouch in the front.

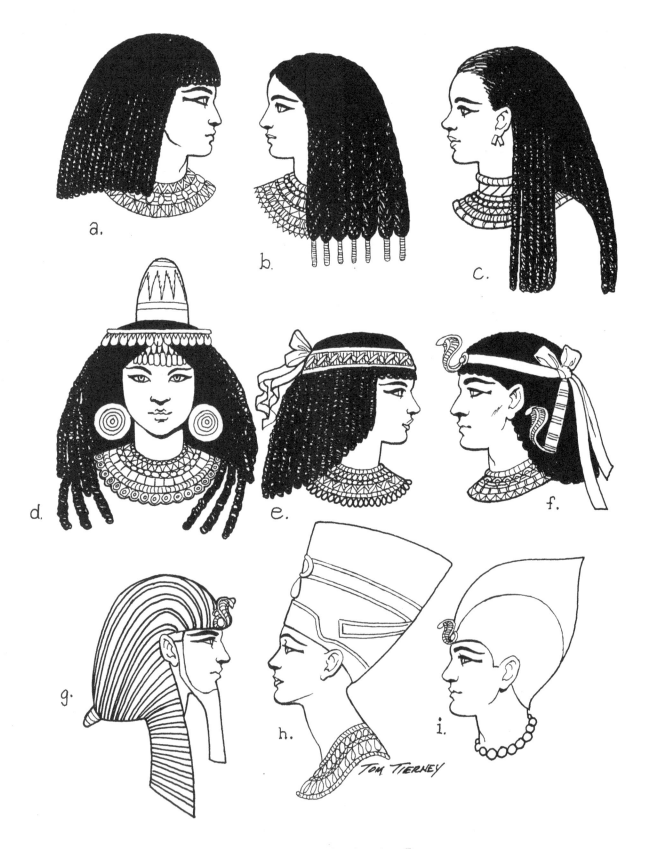

Hair and headdress styles of ancient Egypt.

a. Basic man's wig from the New Kingdom. In the Old Kingdom, the wigs were generally shorter. **b.** A New Kingdom basic wig for women. The hair is corn-rolled and braided. **c.** Woman's wig, hair combed back. **d.** Court entertainer wearing a corn-rolled wig and perfumed cone atop her head. Jeweled circlet, collar, and large disk earrings. **e.** Woman's wig worn with a jeweled headband. **f.** Styled for a king with bands and *uraeus*. **g.** Cloth wig cover called a *khat* or *nemes*. **h.** Queen Nefertiti, with a shaved head, wears a flat topped crown. **i.** Variation of the blue crown. There were at least 23 types of crowns depicted in a single relief dating from

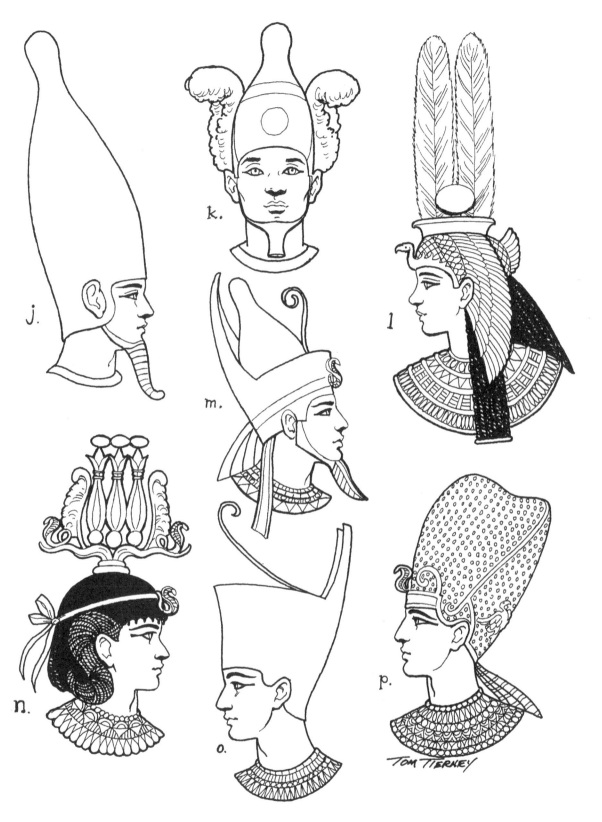

the New Kingdom. **j.** "White Crown" of upper Egypt, dating from pre-dynastic times. **k.** Variation on the "White Crown" with side plumes, from the New Kingdom . **l.** Queen Hatshepsut wearing the royal vulture crown, topped with two plumes and a sun disk. **m.** When Egypt was unified, the "White Crown" and the "Red Crown" were combined. **n.** From the New Kingdom, a prince wears the "Horus lock" of youth. His ceremonial crown depicts goat horns, papyrus bundles, and plumes. Both crown and headband have the *uraeus.* **o.** The pre-dynastic "Red Crown" of lower Egypt. **p.** Ceremonial *cheperesh,* or "Blue Crown", with gold studs and trim.

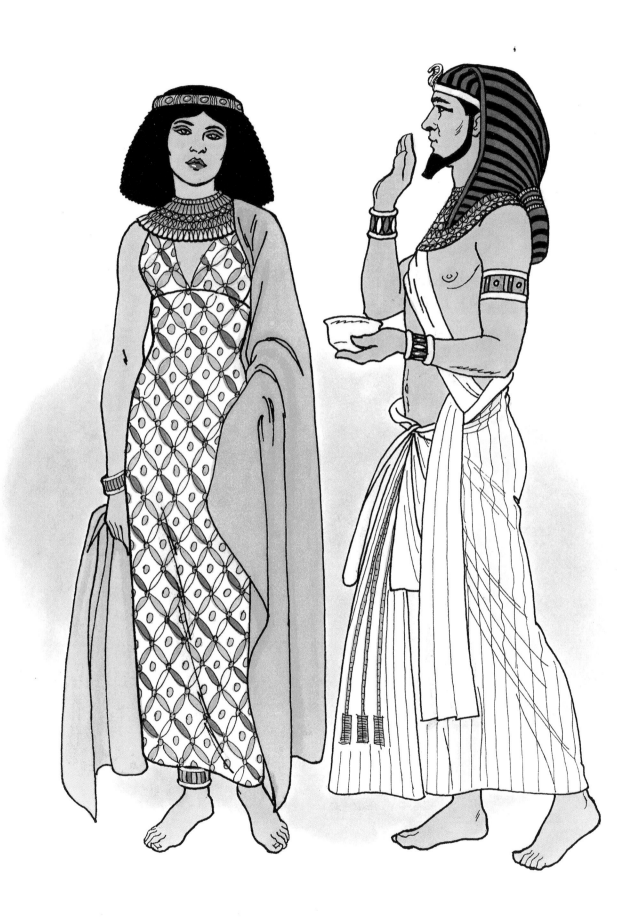

Middle Kingdom. A king and a woman (p. 11)

ANCIENT EGYPTIAN FASHIONS

TOM TIERNEY

Drawing on images from temples, wall paintings, pottery and other artifacts, artist Tom Tierney has created a magnificent ready-to-color panorama of authentic clothing styles worn by the people of ancient Egypt.

Forty-five full-page illustrations depict clothing styles for the highest and lowest members of Egyptian society, including a fashionable sheath worn by an Egyptian princess, a sheer kilt and red crown worn by a king of the Old Kingdom, a pleated skirt for an exotic dancer, a ceremonial robe of leopard skin for Queen Hatshepsut, simply draped gowns for court musicians, a variety of intricately styled wigs, lavish headgear for royal figures, and much more.

Accompanied by accurate representations of period accessories (weapons, fans, symbols of office, musical instruments, etc.), these handsome illustrations are sure to delight coloring book enthusiasts, students of costume design, and fashion historians.

Original Dover (1999) publication. 45 black-and-white line illustrations. 5 color illustrations on covers.

Top: New Kingdom, Osiris (p. 37)
Front cover: left, New Kingdom, A king (p.43)
right, New Kingdom, Queen Hatshepsut (p. 27)

$3.95 USA PRINTED IN THE USA
ISBN-13: 978-0-486-40806-4
ISBN-10: 0-486-40806-X

50395

SEE EVERY DOVER BOOK IN PRINT AT
WWW.DOVERPUBLICATIONS.COM

9 780486 408064